TWELVE MONTHS OF FLOWERS
BY ROBERT FURBER
1674-1756

AN ANTIQUE BOTANICALS
ADULT COLORING BOOK

COPYRIGHT 2016, CAROL MENNIG
ISBN-10: 1533100454
ISBN-13: 978-1533100450

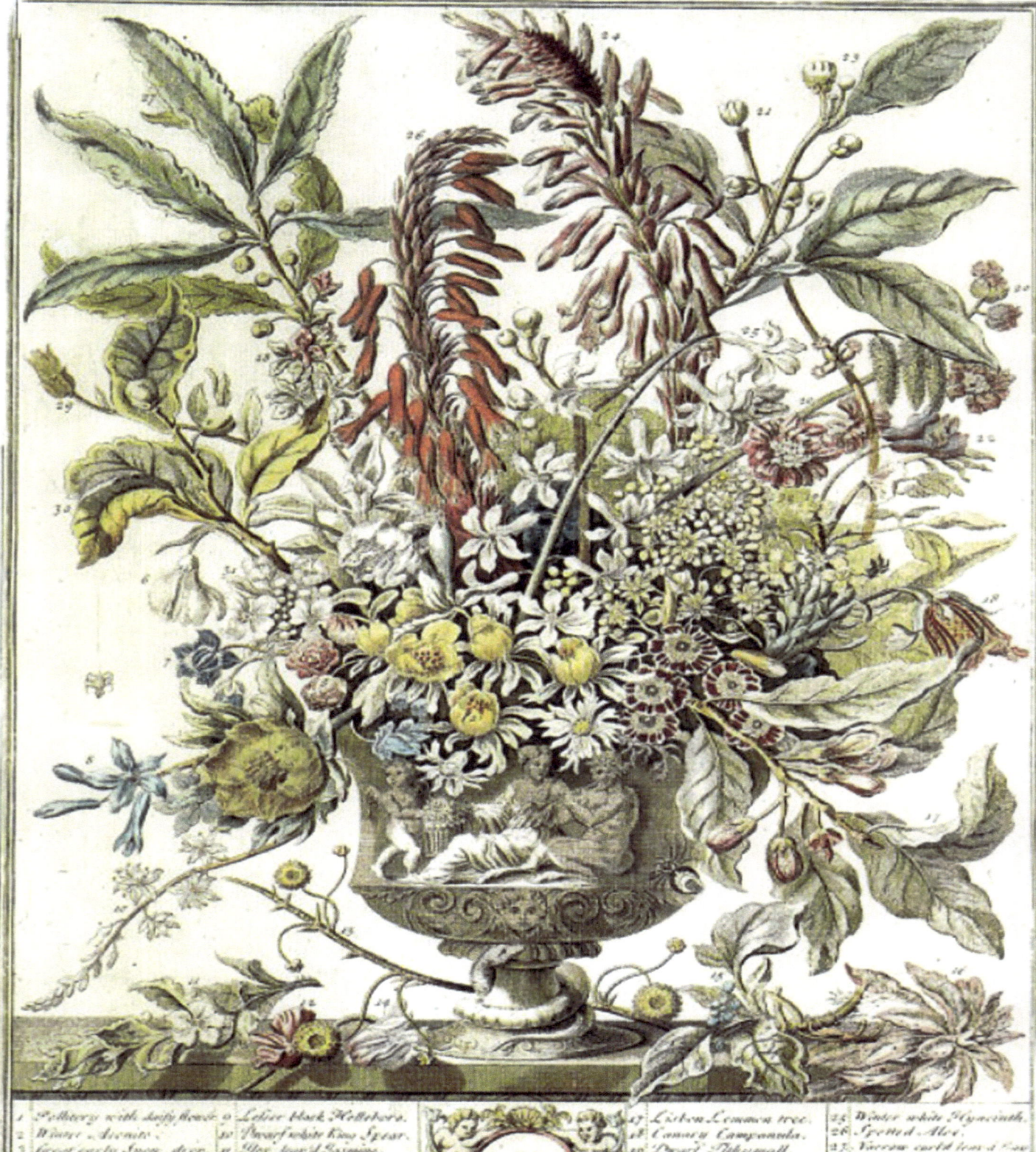

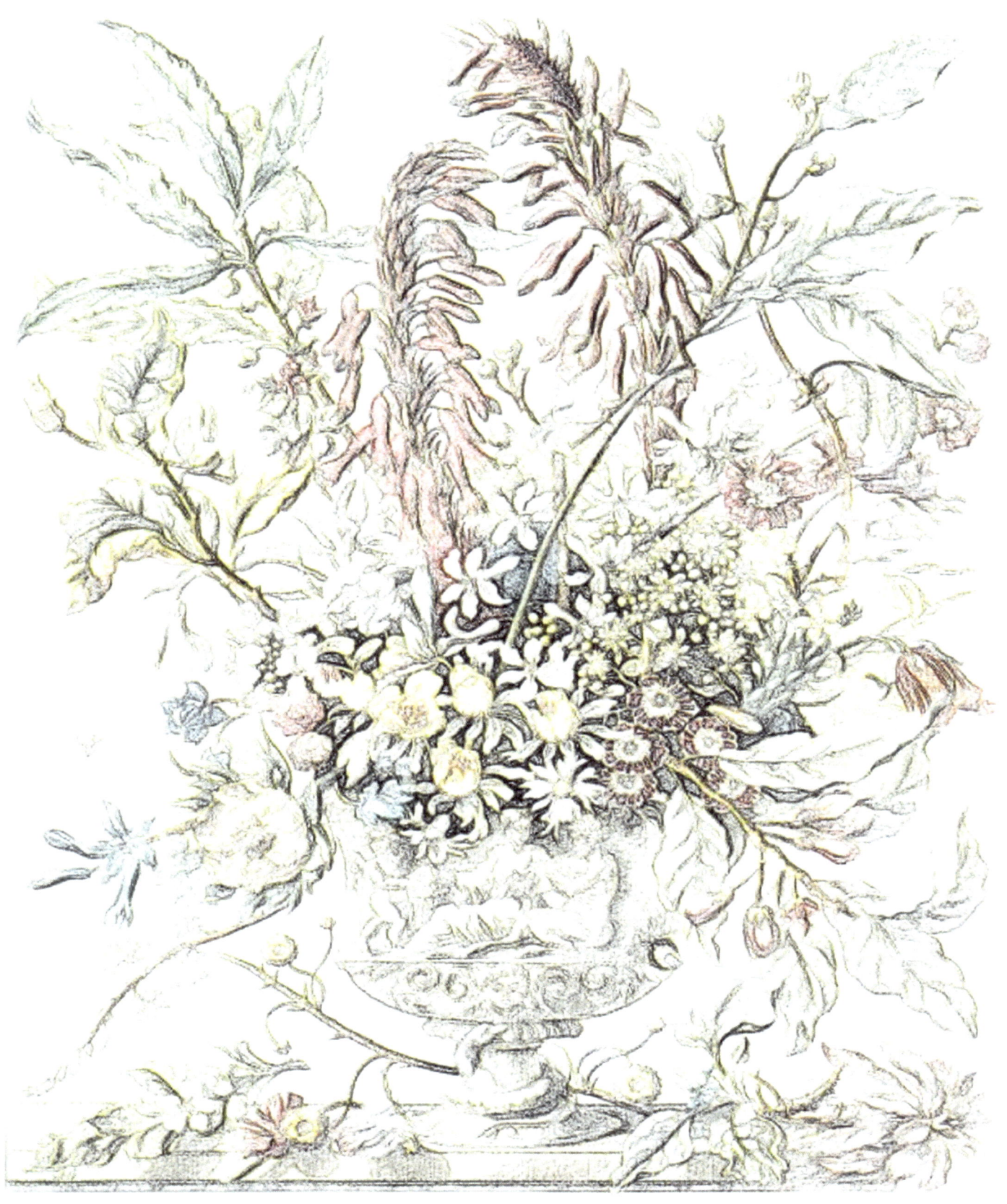

JANUARY

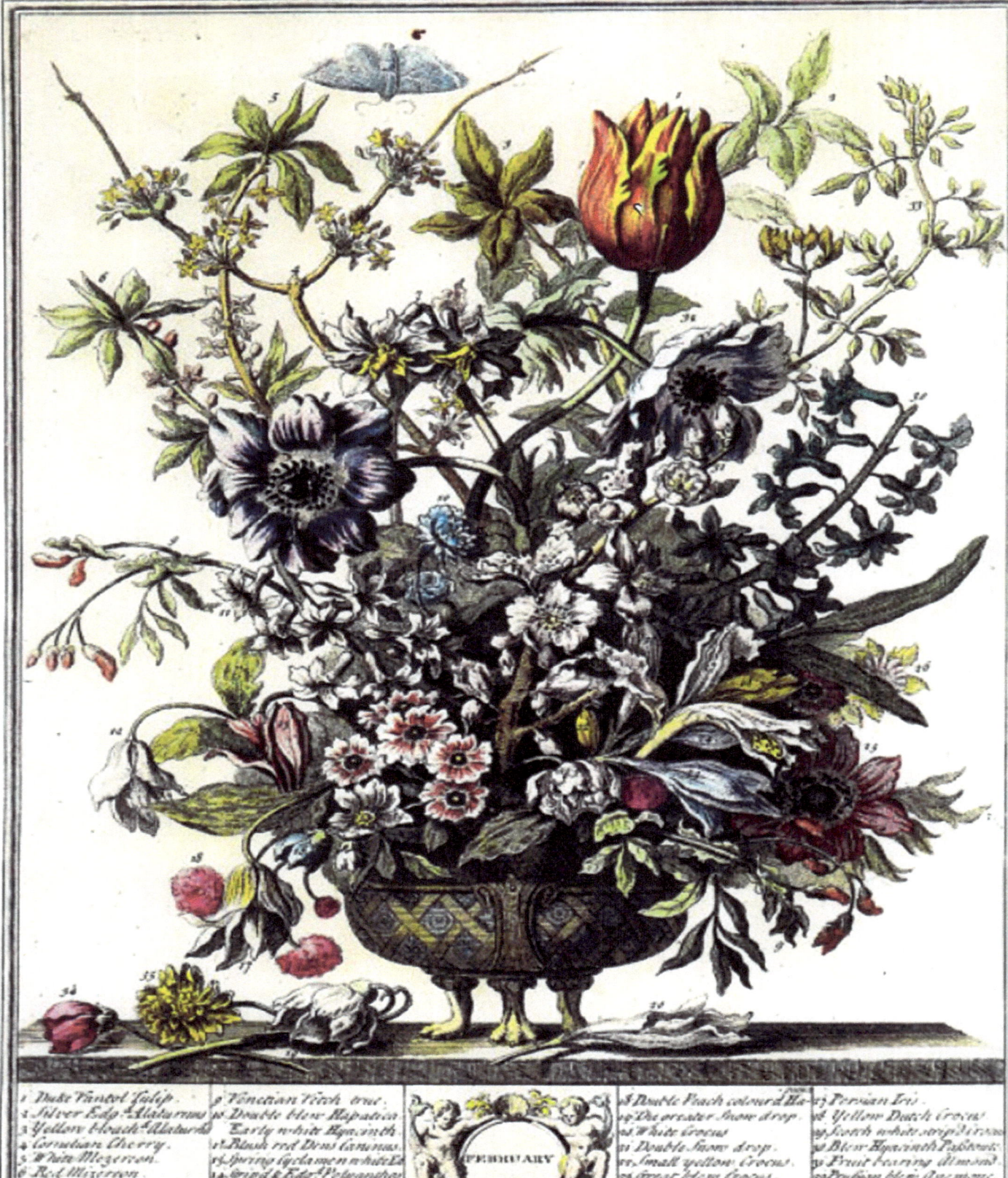

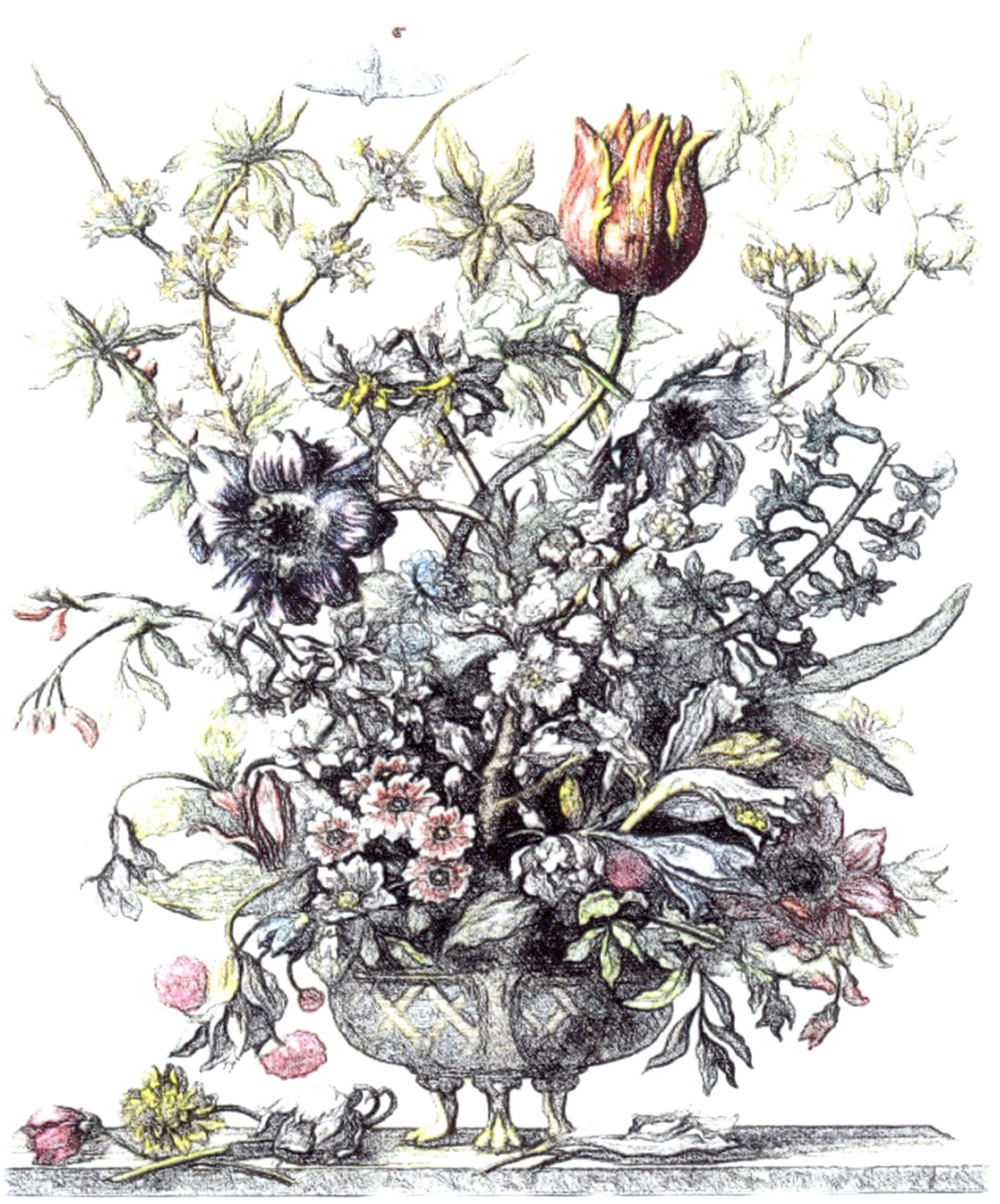

FEBRUARY

1. Royal Widdow Auricula
2. Dwarf white starry Hyacinth
3. White Dortamon Narciss
4. High Admiral Anemone
5. Rhyven Narciss
6. White paste flower
7. White grape flower
8. The lesser black Hellebore
9. Danae Auricula
10. White flowering Almond
11. Dwarf blew starry Hyacinth
12. Sturnian flowering Maple
13. Gold finch Polyanthos
14. Larger blew starry Hyacinth
15. Virginian flowering Maple
16. Narciss of Naples
17. Best Bremen Tulip

MARCH

18. The chequer'd Fritillaria
19. Large leav'd Norway Maple
20. Double pulchra Hyacinth
21. Queen of France Narciss
22. Pale dun flame Tulip
23. Blew Oriental Hyacinth
24. Single bloody Wall
25. Admiral blew Anemone
26. Bell Baptice Anemone
27. Monument Anemone
28. Red flowering Larch tree
29. Blew paste flower
30. Rose Tonker Anemone
31. White flowering Larch tree
32. Purple striped Anemone
33. The Velvet Iris
34. Jerusalem Cowslip

Printed for John Bowles at Mercers Hall in Cheapside

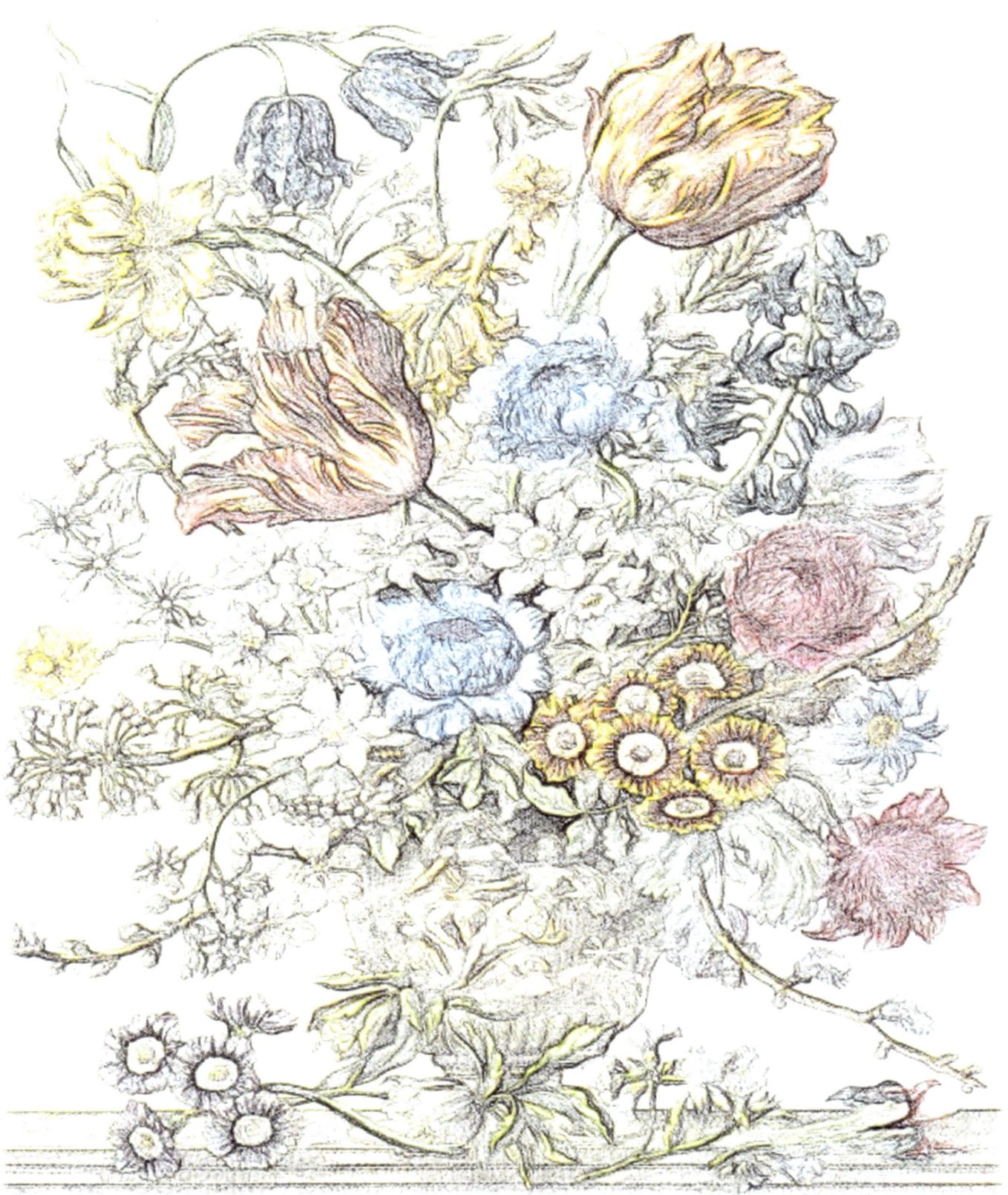

MARCH

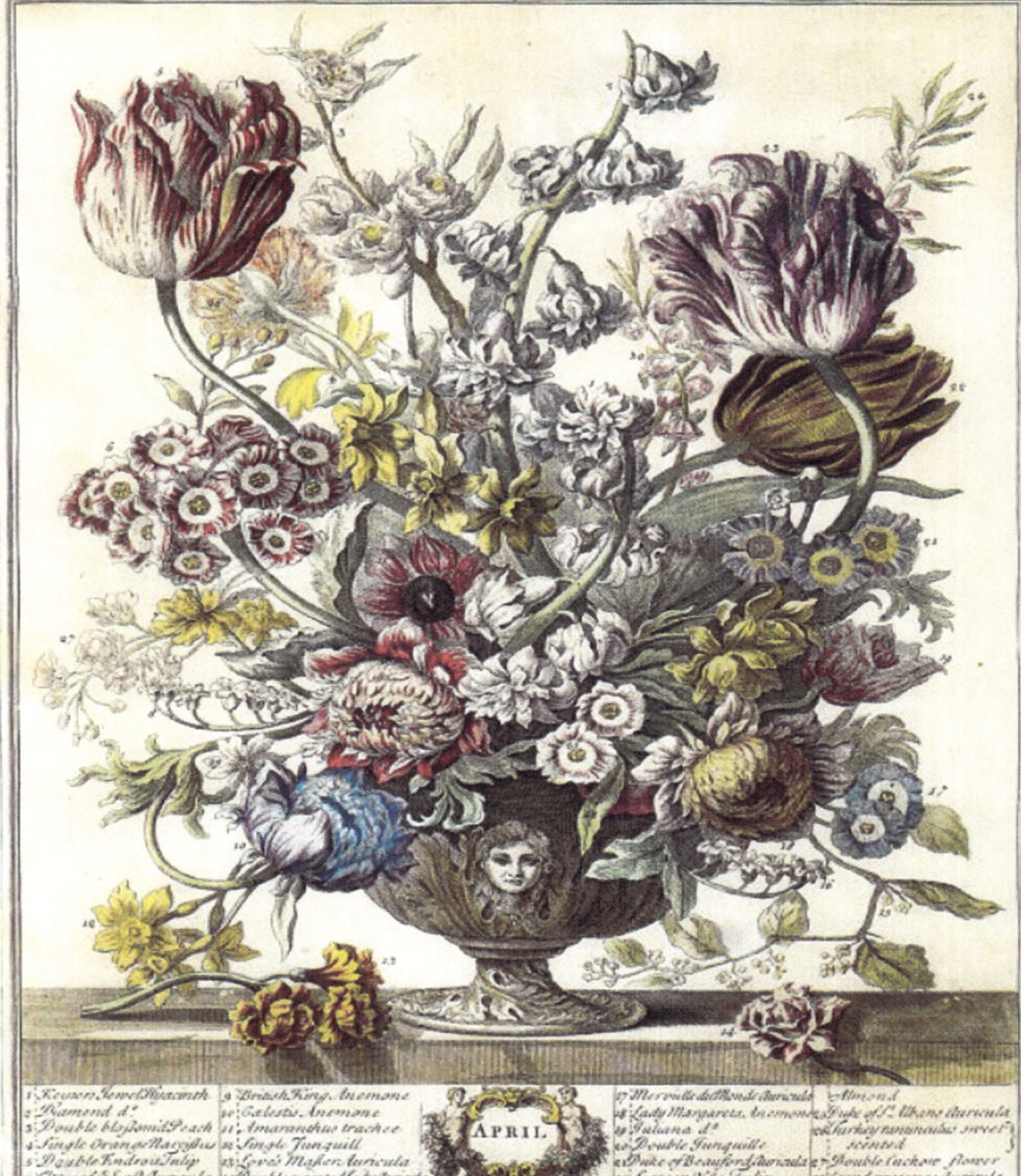

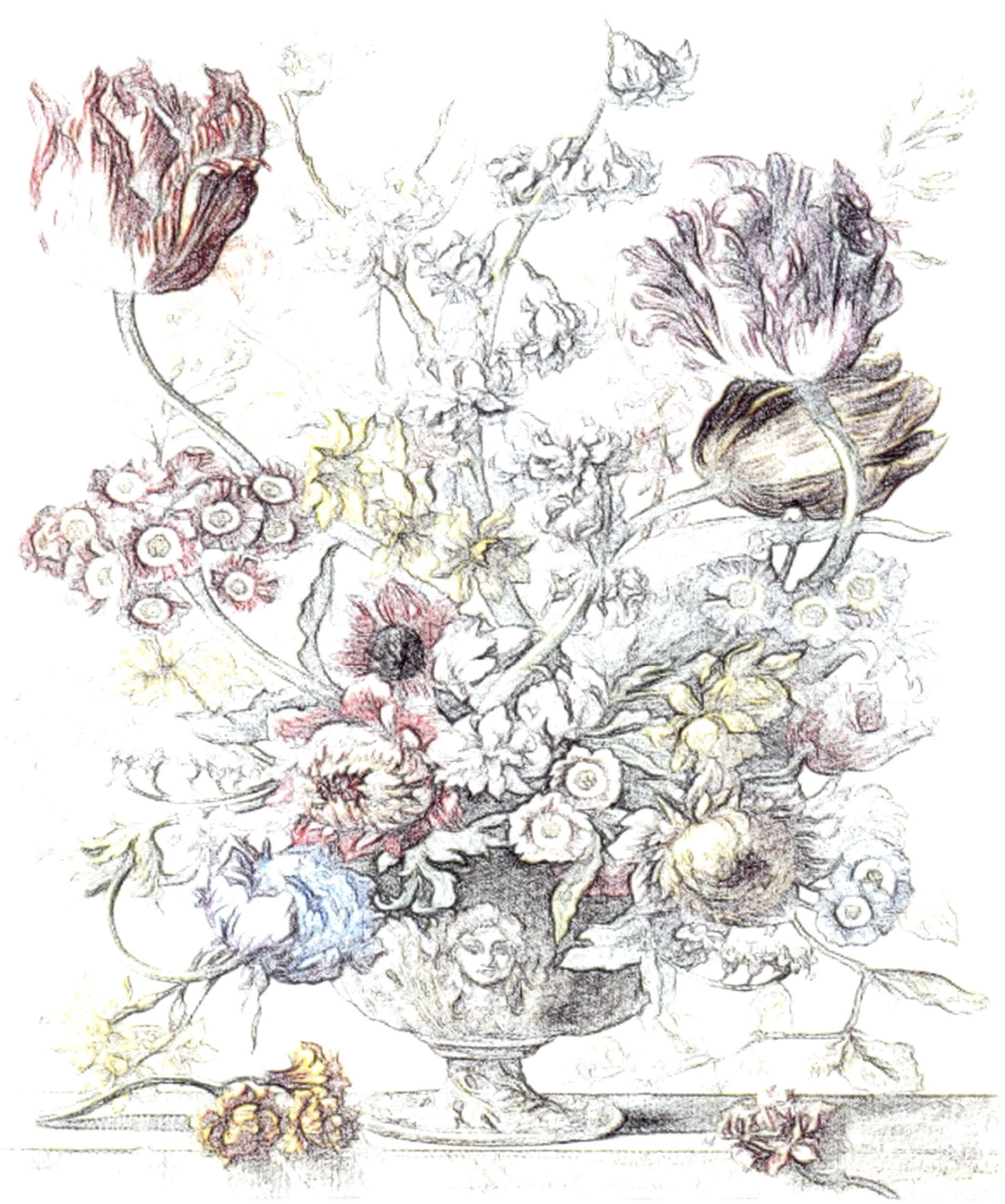

APRIL

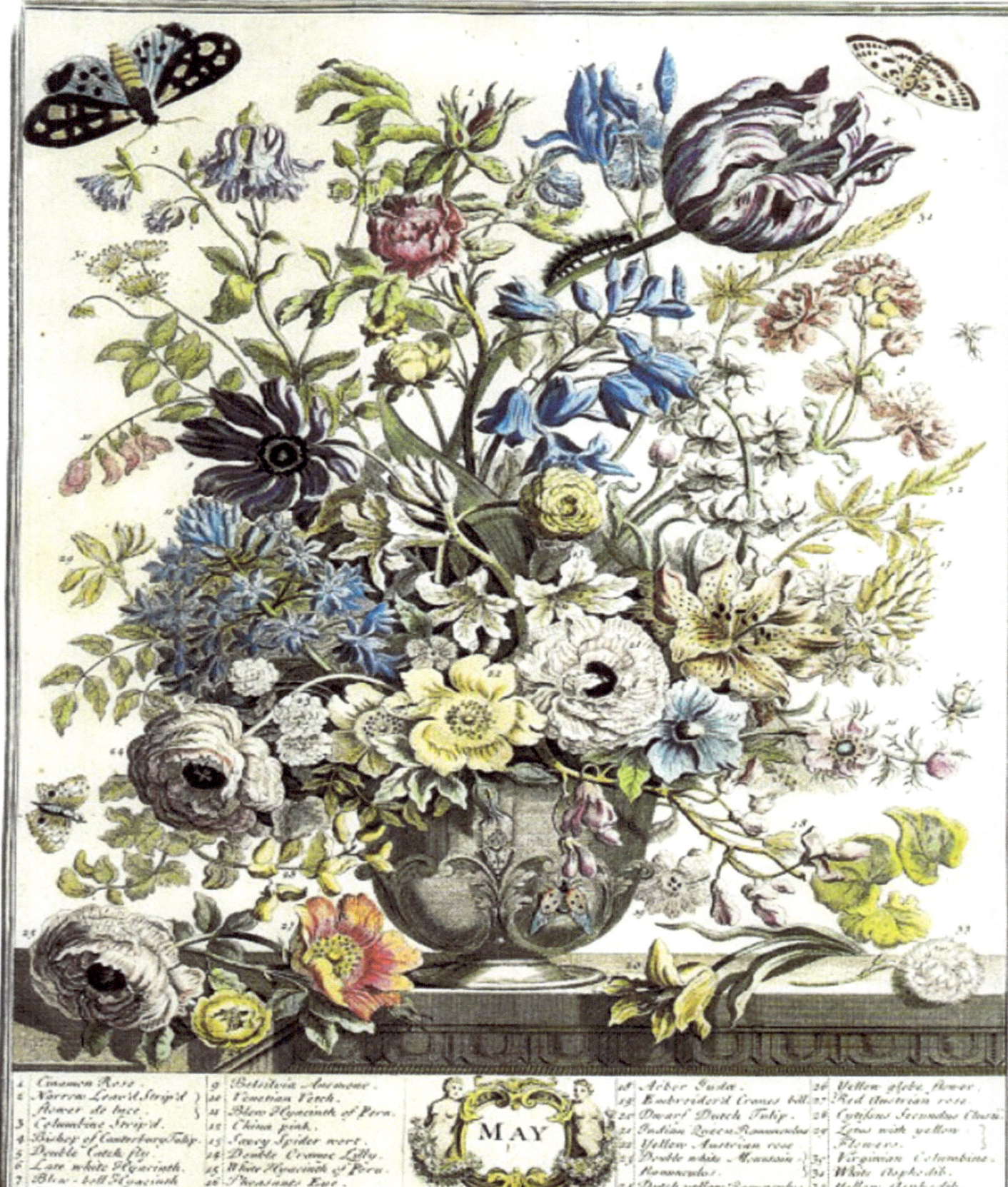

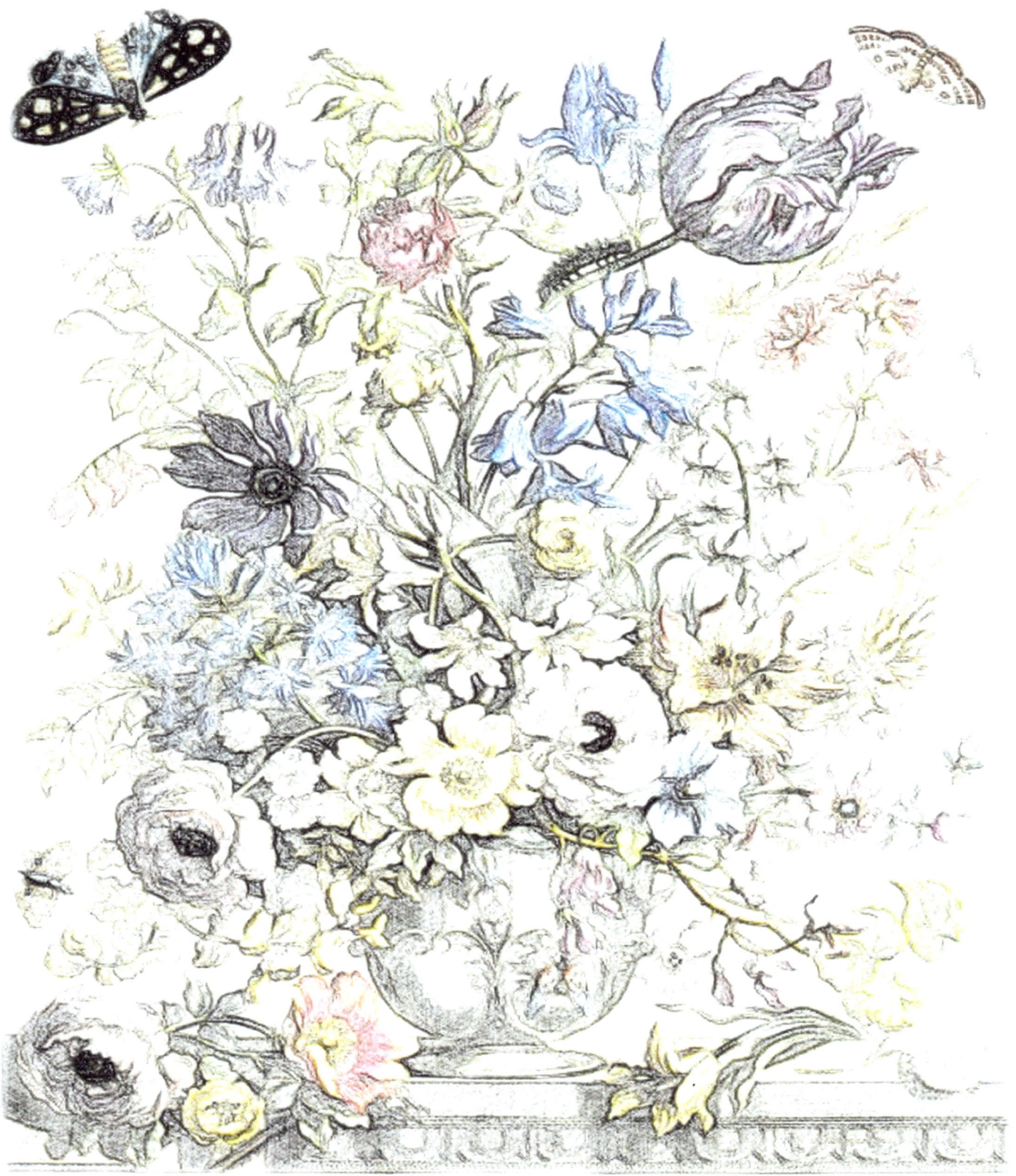

MAY

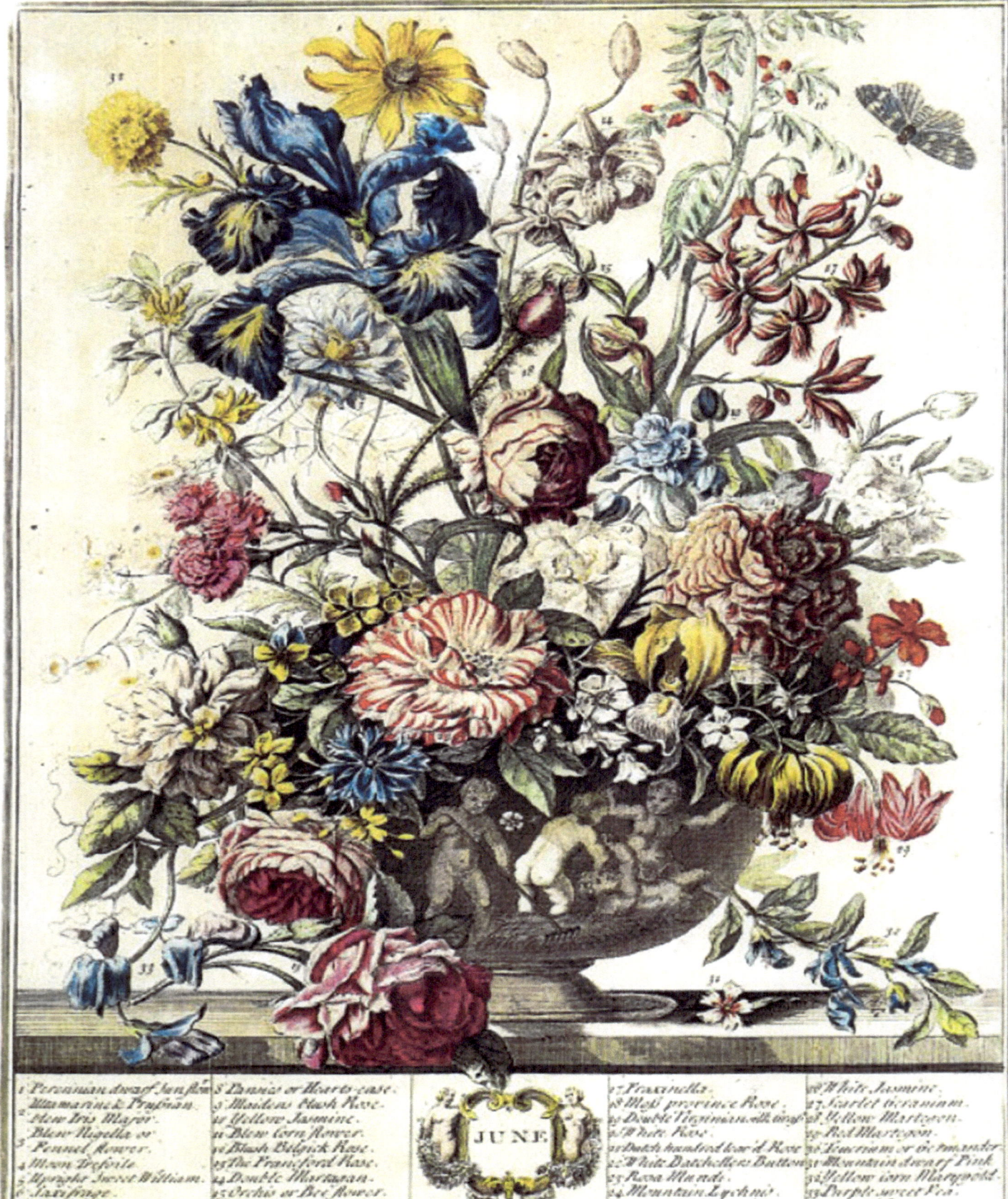

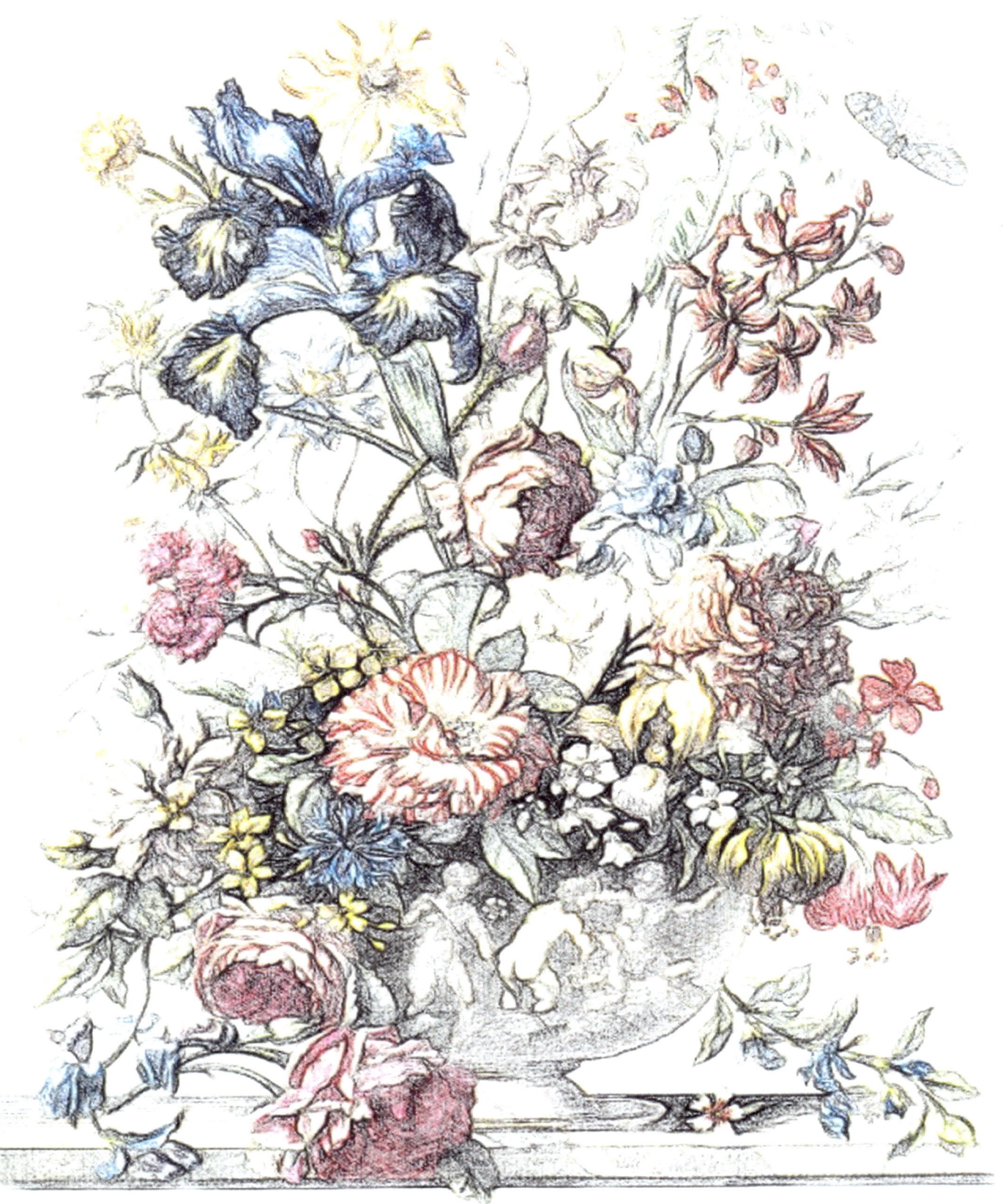

JUNE

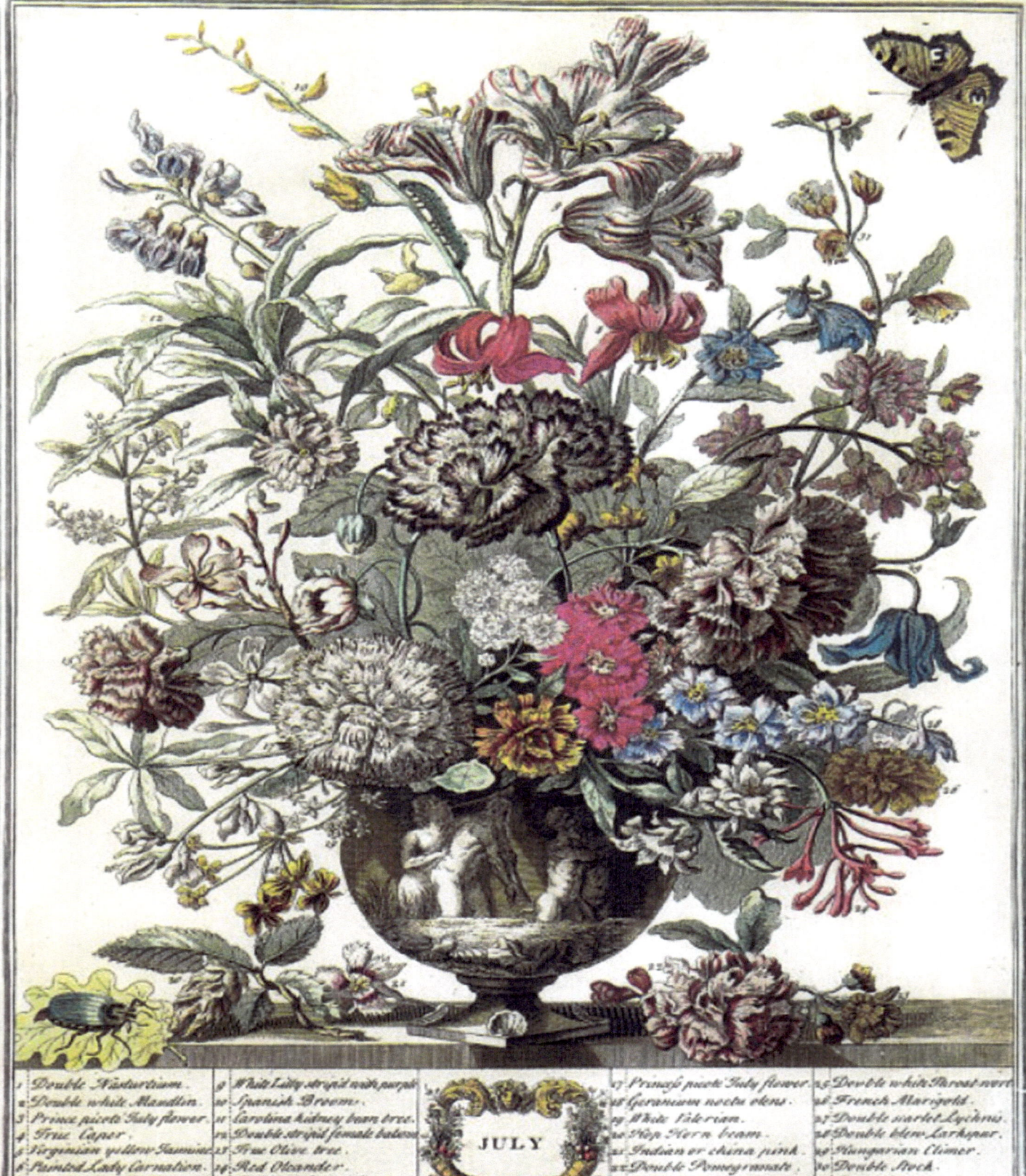

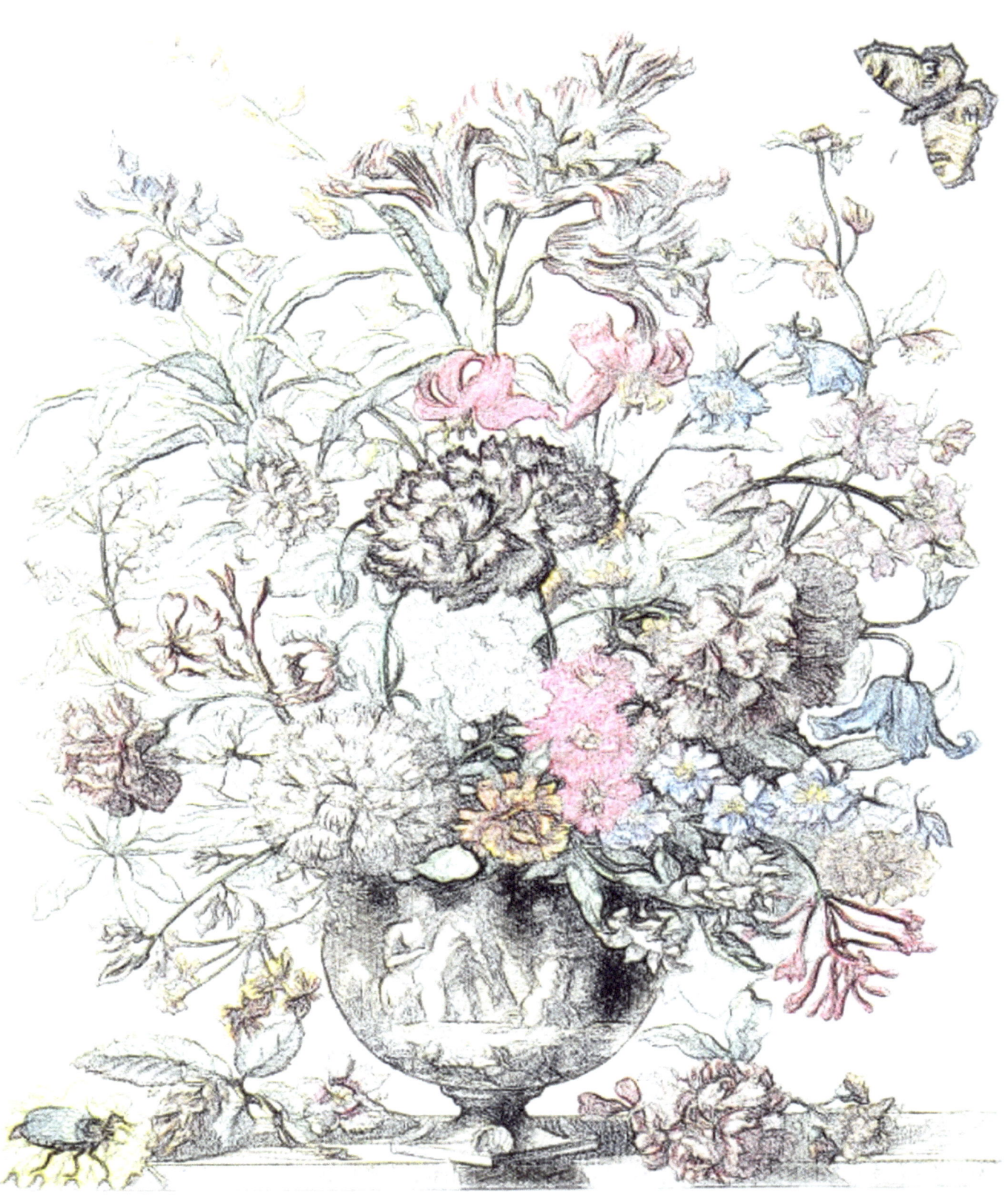

JULY

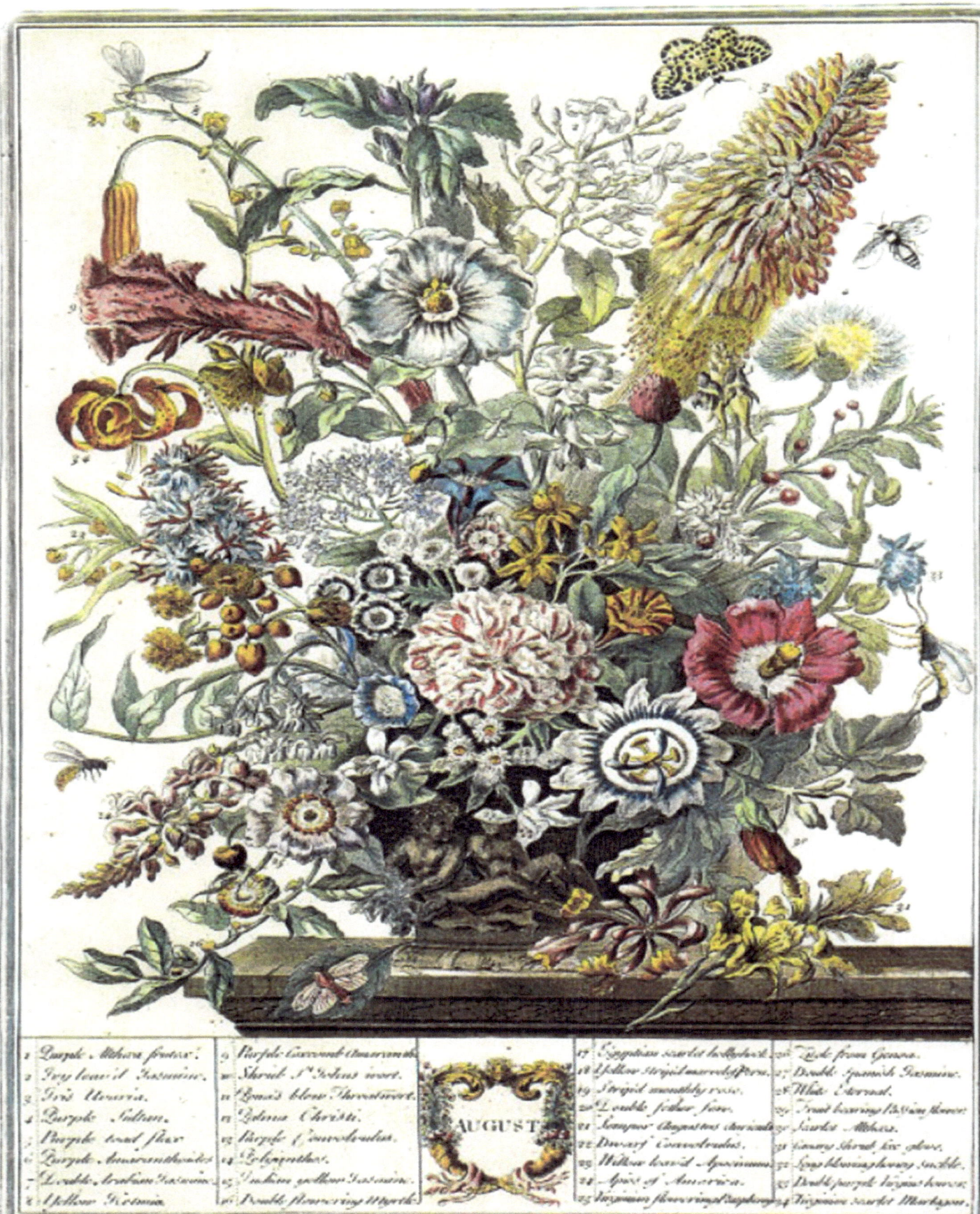

AUGUST

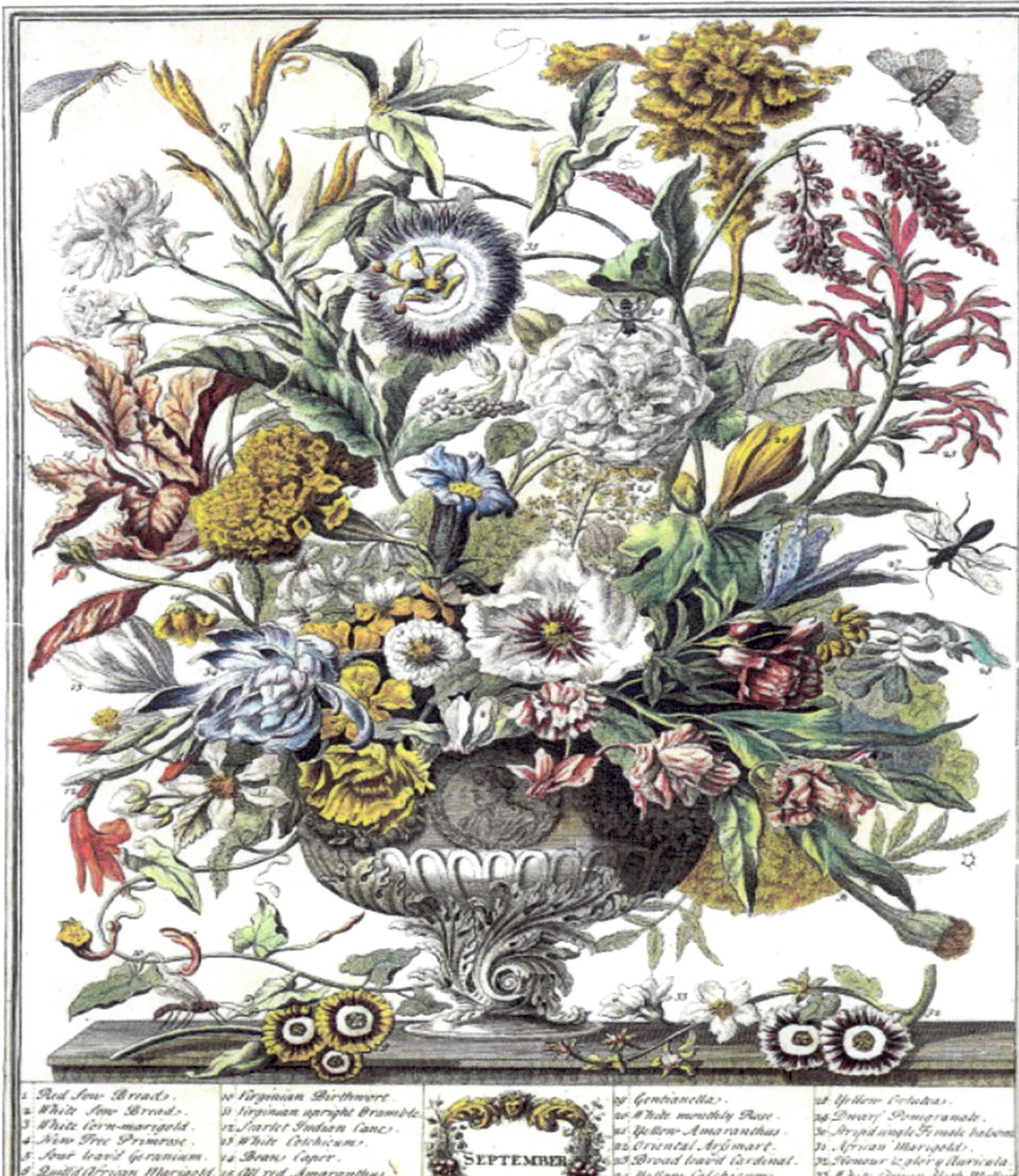

SEPTEMBER

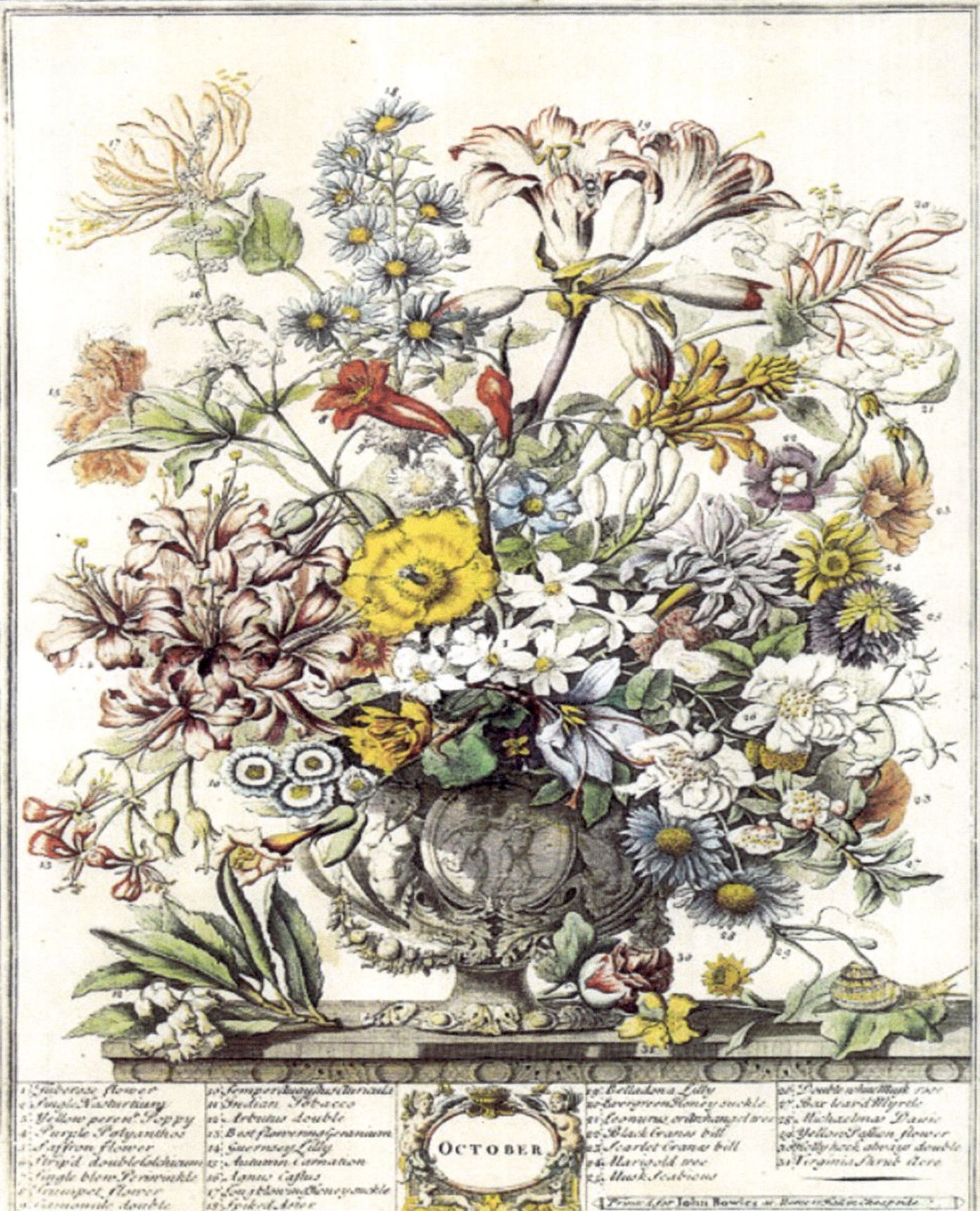

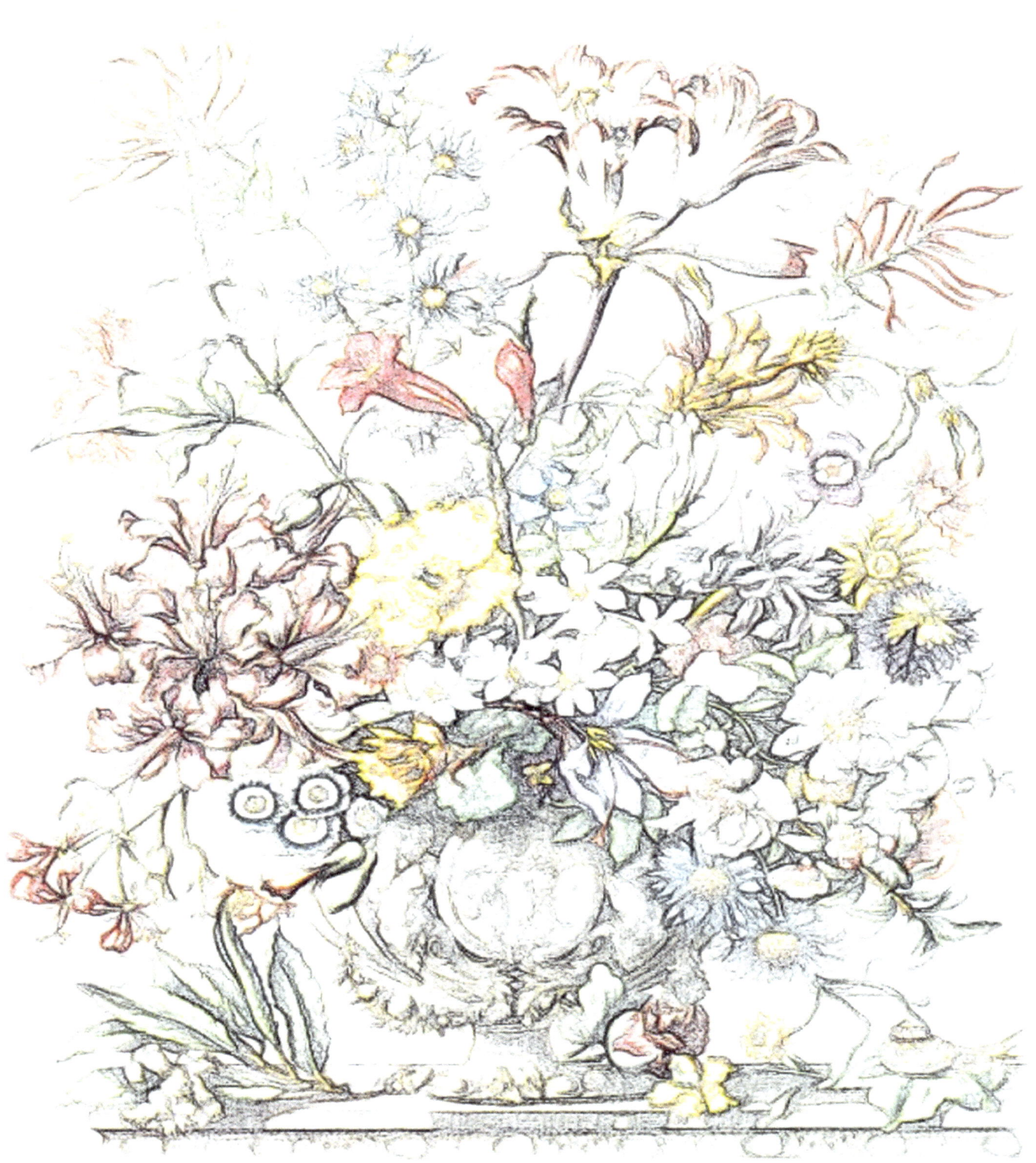

OCTOBER

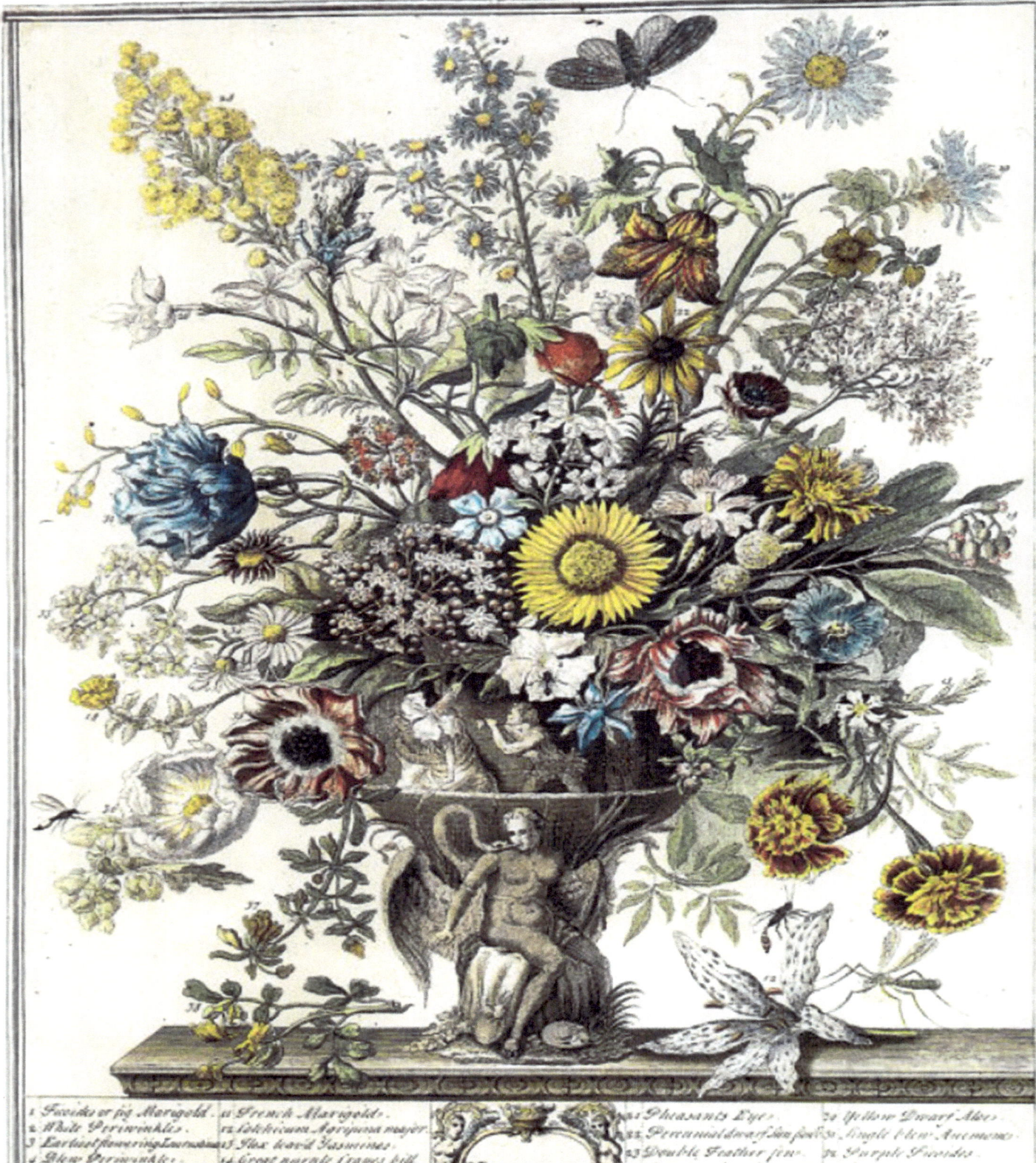

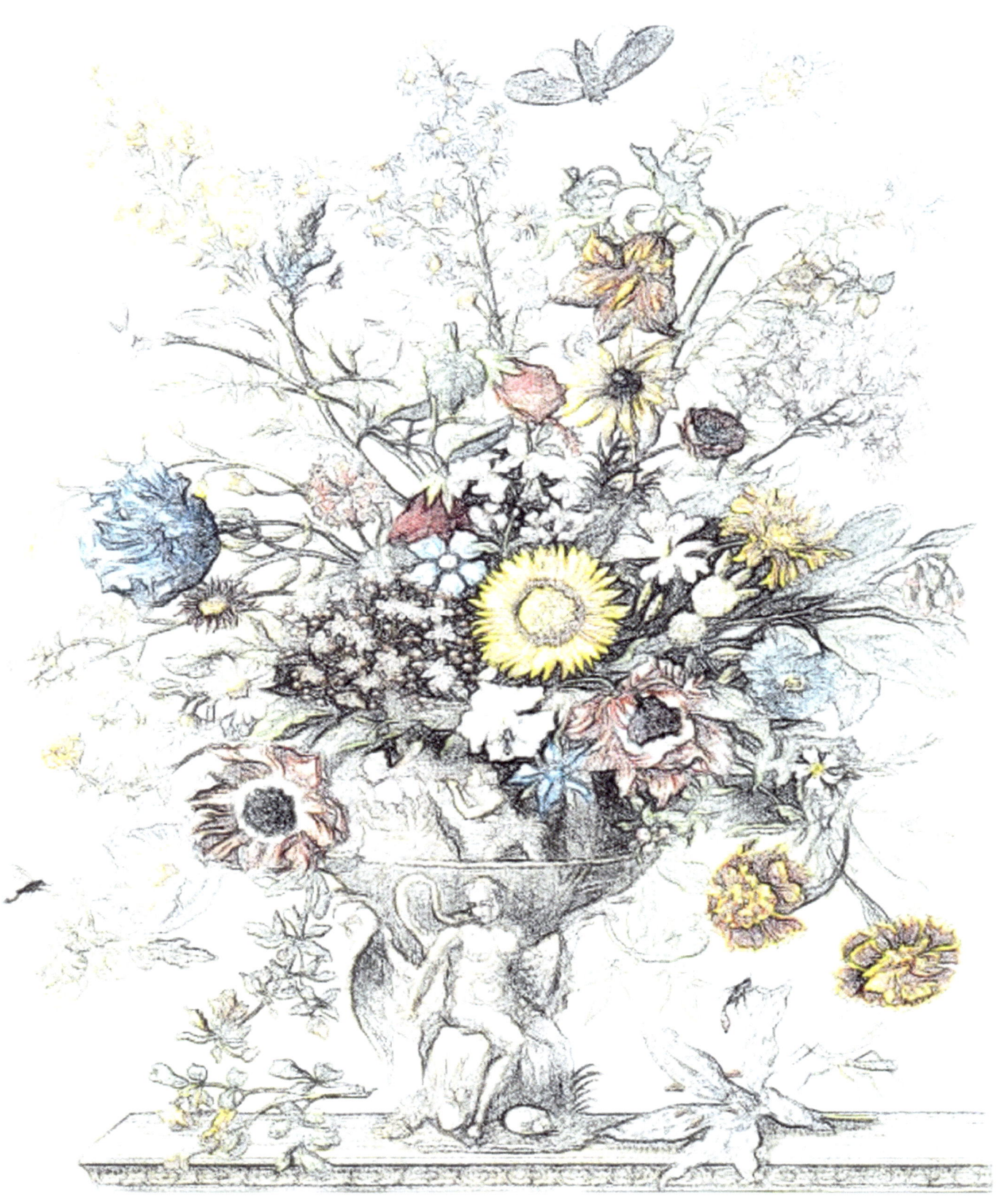

NOVEMBER

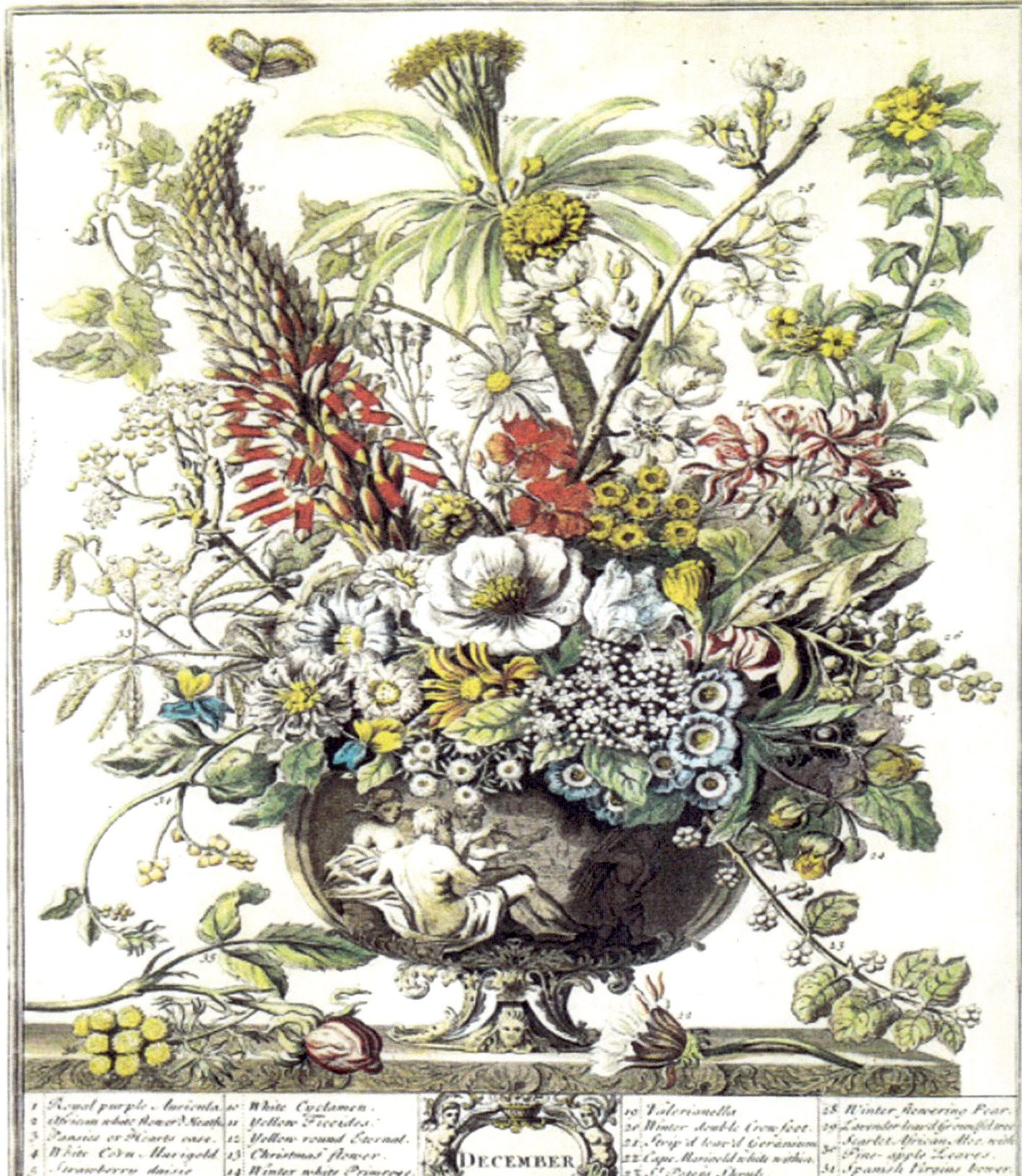

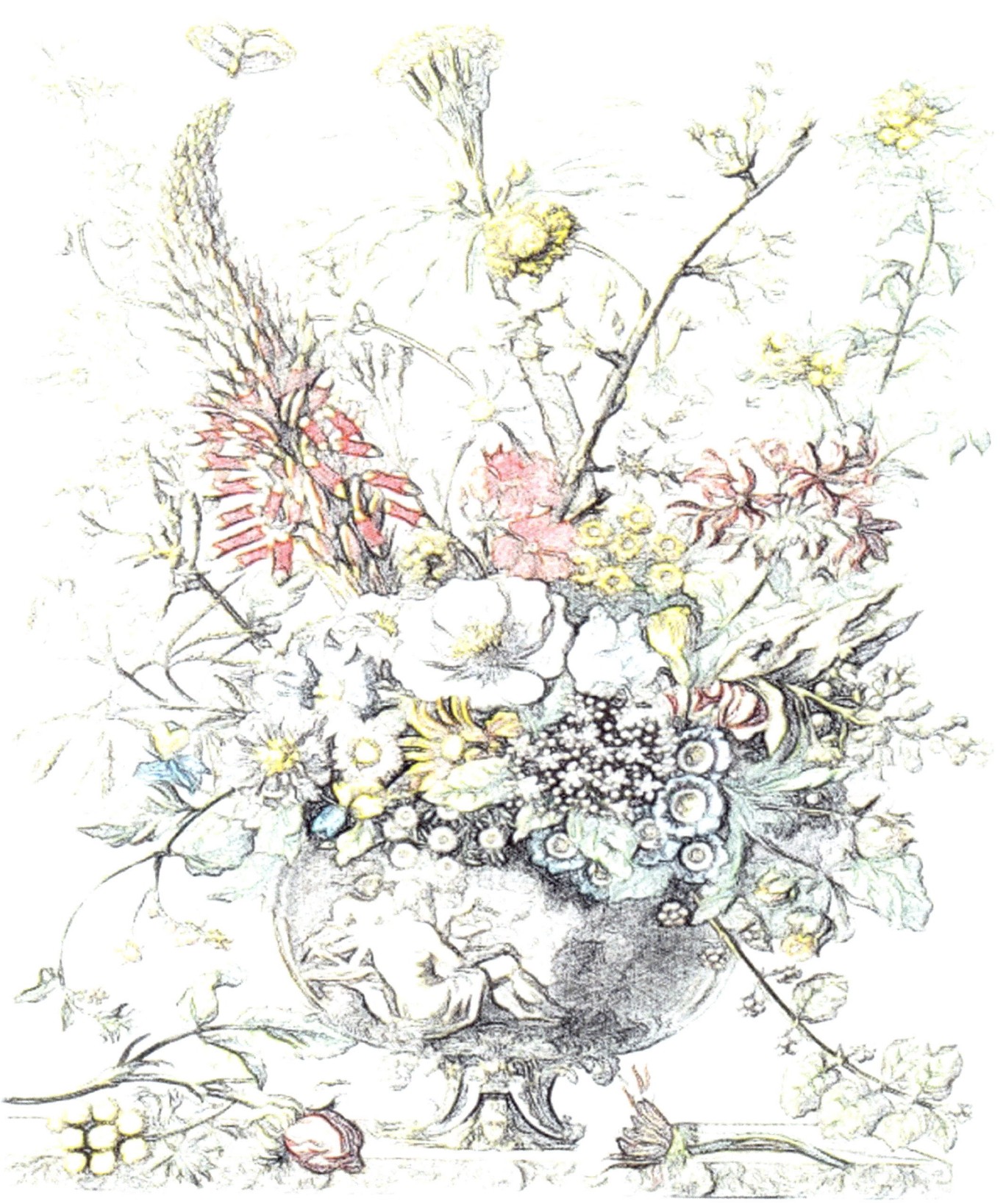

DECEMBER

www.ingramcontent.com/pod-product-compliance
Lightning Source LLC
Chambersburg PA
CBHW040751200526
45159CB00025B/1846